P9-DDI-338

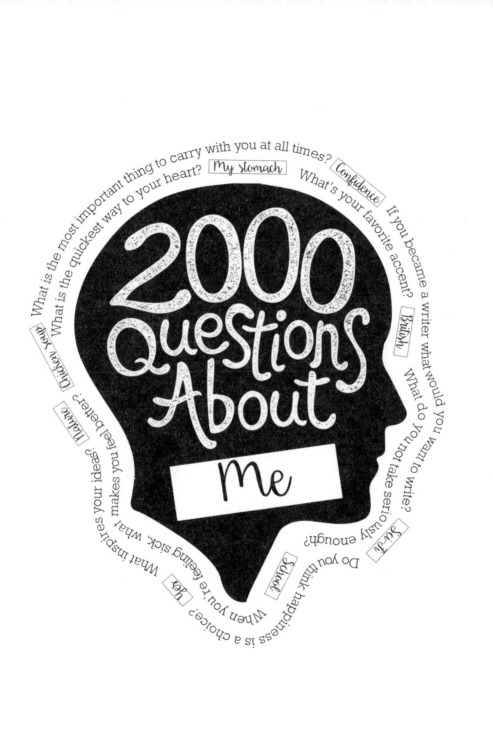

Follow us on social media!

Tag us and use #piccadillyinc in your posts
for a chance to win monthly prizes!

© 2019 Piccadilly (USA) Inc.

This edition published by Piccadilly (USA) Inc.

Piccadilly (USA) Inc.
12702 Via Cortina, Suite 203
Del Mar, CA 92014
USA

All rights reserved. No part of this publication may be reproduced, stored in a retrieval system,
or transmitted in any form or by any means, electronic, mechanical, photocopying, recording,
or otherwise, without prior consent of the publisher.

10 9 8 7 6 5 4 3 2 1

Printed in China

ISBN-13: 978-1-62009-166-1

1 What is your idea of perfect happiness?

2 What is your greatest fear?

3 What is the trait you most deplore in yourself?

4 What is your greatest extravagance?

5 What is your current state of mind?

6 What do you consider the most overrated virtue?

7 On what occasion do you lie?

8 What do you most dislike about your appearance?

9 Which living person do you most despise?

10 What is the quality you most like in a man?

11 What is the quality you most like in a woman?

12 Which words or phrases do you most overuse?

13 What or who is the greatest love of your life?

14 If you could change one thing about yourself, what would it be?

15 What do you consider your greatest achievement?

16 If you were to die and come back as a person or a thing, what would it be?

17 Where would you most like to live?

18 What is your most treasured possession?

19 What do you regard as the lowest depth of misery?

20 What is your favorite occupation?

21 What is your most marked characteristic?

22 What do you most value in your friends?

23 Who are your favorite writers?

24 Who is your hero of fiction?

25 Which historical figure do you most identify with?

26 Who are your heroes in real life?

27 What is your greatest regret?

28 How would you like to die?

29 What is your motto?

30 Do you like watching reruns?

31 Have you ever won any kind of contest yourself?

32 What gives you cheap thrills?

33 What do you think is worth waiting for?

34 Are you an organ donor, if so why/why not?

35 Should parenting classes be mandatory for new parents?

36 What is the number one thing people are always asking you for help with?

37 What movie did you love the original but hate the sequel?

38 Are you more talk and less action or vice versa?

39 Have you ever given someone a handmade present?

40 Do you think Great Britain should be part of a united Europe?

41 Have you ever eaten a whole tube of Pringles by yourself?

42 Do you like champagne, if so what is your favorite brand?

43 What nervous habits do you have?

44 What do you do when you and your best friend get into a fight?

45 What do you think should be a wonder of the world that currently isn't?

46 What comforts you on bad days?

47 Do you treat yourself and your body with respect?

48 Something you eat that other people would find gross.

49 Have you ever broken the law and didn't get caught, if so how?

50 Something you fear might change you.

51 What personality trait in people raises a red flag with you?

52 Have you ever resented someone, if so what for?

53 How have you changed over the last 5 years?

54 Have you ever painted a house?

55 Have you ever had a surprise party (that was an actual surprise)?

56 What makes you feel miserable?

57 What's the best costume you've ever worn?

58 What's been the hardest loss you've had to take?

59 Do you like sunny days or rainy days more?

60 What does your typical Friday night look like?

61 Who is your favorite movie director and what's your favorite movie from them?

62 What is the furthest you've ever got a paper airplane to fly?

63 Do you like the person you're becoming?

64 What's the highest you've ever jumped into the water from?

65 What do or did you hate most about dating or the dating process?

66 How emotional are you?

67 Have you ever had an internship, if not what would be your dream intern job?

68 Do you prefer chicken, beef or seafood?

69 Have you ever had a health scare?

70 What do you love most about the holiday season?

71 Do you think a fling could be a good thing?

72 What part of your routine do you always try to skip if you can?

73 What inspires your ideas?

74 What do you frown upon when it comes to raising kids?

75 Have you ever been professionally photographed?

76 Where or how do you find serenity?

77 Do you influence people more than they influence you?

78 What can you do to make your life better?

79 Do you buy anything organic, if so what?

80 Describe yourself in terms of food.

81 How could you reinvent yourself?

82 What was the name of the first album you ever bought and who was it by?

83 What is your Chinese zodiac sign and is the description accurate?

84 Do you have any prejudices you've admitted to yourself?

85 Who is the very first friend you ever remember making and how old were you?

86 What makes you lose sleep?

87 What are 3 phrases or sayings you say almost every day?

88 Do you floss or use a toothpick when food gets stuck in your teeth?

89 Have you ever swerved off the road to avoid hitting something?

90 Compare your driving skills to something?

91 What food is romantic to you?

92 How easy is it for you to get along with people?

93 Has someone ever given you a "last chance" and for what?

94 Something on your "to-do list" that never gets done.

95 What's your favorite thing to eat with your fingers?

96 What is your favorite or most used cookbook?

97 What food best describes your personality?

98 Would you ever do a ride along with a cop, if so what do you want to see?

99 Do you think ignorance is bliss?

100 Are you a pacifist?

101 What do you need to do to grow?

102 What is something you wish you learned?

103 Where's your favorite place to order pizza?

104 Who taught you how to drive?

105 Have you ever helped someone across the road?

106 What is legal that you think should be illegal?

107 Would you rather own a private jet or luxury yacht?

108 What's the first impression you want to give people?

109 Which would you rather have if you had to, a broken leg or a broken arm?

110 What profession do you think is the most undervalued today?

111 What is your favorite thing to put icecream on or eat icecream with?

112 Who would you love to collaborate with and what would you collaborate on?

113 Where do you cut costs when you need to save?

114 What was one thing you begged your parents for as a kid and they finally gave it to you?

115 If you could have someone serenade you over a candle light dinner, who would it be?

116 Do you think horoscopes are accurate?

117 How do you describe millennials?

118 Do you have a pet, if so what kind?

119 If you were a bartender what famous person would you like to serve?

120 If you could choose your last words, what would they be?

121 Do you have a calling on your life?

122 Have you ever let someone win an argument even if you knew you were right, if so who?

123 Could you ever be a medical guinea pig?

124 What is the most annoying thing about the opposite sex?

125 How do you feel about investing your money?

126 What is something you'd like to grow instead of buying?

127 How do you like to take your coffee or tea?

128 How smart is your significant other, who is smarter?

129 What is your preferred swimming stroke?

130 Have you ever had something snowball out of control, if so what?

131 Were you popular in school, if so what made you popular?

132 What risk would you take if you knew you wouldn't fail?

133 What was an offer you couldn't refuse?

134 Do you believe in angels?

135 If you were guaranteed the correct answer to one question, what would you ask?

136 Would you rather lose all of your old memories or never be able to make new ones?

137 Have you ever been at the wrong place at the wrong time, where?

138 Have you ever been whistled at in public?

139 What is something totally relatable to you?

140 What's the best pickup line you've ever heard?

141 Would you ever steal to provide for your family?

142 In your opinion who do you consider a visionary?

143 If you could live forever, would you want to?

144 Have you ever touched a snake or would you?

145 What do you think gets better with age?

146 Do you ever forward or reply to chain mails?

147 What scientist in history is most credible?

148 Have you ever been called immature, if so what were you doing to be called that?

149 Is there a place in your neighborhood or city you've been meaning to visit, if so where?

150 What slogan or jingle got stuck in your head forever?

151 Could you ever grow your own food?

152 If you could be a bird, which would you be?

153 Do you watch foreign films, if so do you have a favorite?

154 What specific work of art do you admire the most?

155 Which are cooler: dinosaurs or dragons?

156 Has your work ever come between a relationship you were in, if so how?

157　If you could have a clone to help you out when life gets busy, would you want one?

158　What are you "self-taught"?

159　The Beatles or Rolling Stones?

160　What do you try and keep an open mind about?

161　Would you rather ride along with a firefighter or police officer for a day?

162　Do you believe in the saying kill your enemies with kindness?

163　What do you love most about the night sky?

164　In an argument do you have to have the last word?

165　Have you ever participated in a fundraiser, if so for what cause?

166　What is the heaviest thing you can lift?

167　Would you ever consider training for a triathlon?

168　What is your perfect pairing for coffee?

169　How strict are you going to be as a parent?

170 What's your favorite hobby?

171 Do you think a person can be born evil?

172 Do you believe in PDA (public displays of affection)?

173 Would you date anyone in a wheelchair or with a handicap?

174 What is an article of clothing you've bought or received second hand and loved wearing?

175 Who would you rather hang out with for a day–Superman or Batman?

176 What makes you feel secure?

177 Do you sing in the shower?

178 What makes you feel inadequate?

179 What does your perfect weekend consist of?

180 If you could live anywhere, where would that be?

181 Do you have a nerdy side, if so what brings it out?

182 Do you think children are a blessing or a burden?

183 What is your greatest source of inspiration?

184 What's the wildest thing you've ever done?

185 If you could be trained in any one thing by top professionals what would you choose?

186 What is the highest hill or mountain you've ever climbed?

187 Do you think making driverless cars is a smart invention?

188 Use a cartoon character to describe your athletic ability.

189 Do you like to plan things out in detail or be spontaneous?

190 Do you like living alone or with someone?

191 Do you make time for what matters most for you?

192 What makes you feel unattractive?

193 How many hats do you own?

194 Have you ever contributed to the development of something you were proud of?

195 What is your favorite song to sing in the shower?

196 What is your opinion on rats as pets?

197 Were you ever really passionate about something then suddenly lost interest, what was it?

198 Which was your favorite science? Biology, physics or chemistry?

199 Can you erect a tent?

200 Have you ever received counseling or therapy and did it help?

201 Have you ever sued or wanted to sue someone, why?

202 Who would you want to star opposite you, if you were in a movie?

203 Do you believe in the death penalty?

204 Have you ever done something to your parents that you regretted?

205 Have you ever nicknamed someone and it stuck, if so who and what was the nickname?

206 If you knew you would die tomorrow, would you feel cheated today?

207 Who influenced your life the most?

208 What is the simplest truth you can express in words?

209 Do you prefer music on vinyl or streaming?

210 What do you do when you get nervous?

211 Where's your favorite place to get coffee or tea?

212 Did you ever have an embarrassing moment in gym class in school?

213 What do you love most about yourself?

214 If you started a business tomorrow what would it be?

215 What is one thing you've learned about people over the years?

216 How judgmental are you towards other people?

217 What's your ratio of naughty to nice?

218 What is history's most tragic love story in your opinion?

219 Have you ever went after anything (job, relationship, etc.) and didn't get it?

220 Which activities make you lose track of time?

221 In what way has money impacted you negatively?

222 How was your very first kiss?

223 What age would you not want to live past?

224 What celebrity do you think got carried away with plastic surgery?

225 If you could hire any wedding singer, who would you choose and what song?

226 What age do you think is too young to get married?

227 What one thing do you think all successful leaders have in common?

228 Have you ever donated blood and if so do you do it regularly?

229 Do you have a birthmark, if so where?

230 Do you prefer watching a movie at home or at a theater?

231 Are you much of a gambler?

232 Do you believe confession is good for the soul?

233 If you could own one famous original work of art, what piece would it be?

234 Do you sometimes spend money you don't have or live above your means?

235 Would you break the law to save a loved one?

236 Do you like to receive bad news sugarcoated or bluntly?

237 Do you think celebrities should be looked at as a role model or just for entertainment?

238 Do you believe in God or a higher power?

239 Where is your favorite place to meditate?

240 If you ever decided to run for President, what would be your campaign slogan?

241 After a long, hard day at work or school, what do you like to do?

242 If you could bankrupt one person or company who would it be?

243 Who texts you the most, and why?

244 What's the best excuse you've given or would give to a bill collector?

245 If you were going on *Dancing with the Stars*, whom would you want as your partner?

246 Have you ever made your own icecream?

247 Do you prefer your hair longer or shorter?

248 Describe Mondays for you in one word.

249 Have you ever ran out of gas in your car, if so where?

250 What does honor mean to you in a few words?

251 Have you ever been on a group outing, where did you go?

252 Do you like throwing parties?

253 Have you ever been on TV?

254 What is your idea of moral support?

255 Do you own a camera and if so what was the last photo you took?

256 If you could challenge anyone to a boxing match, whom would you want to fight?

257 What do you think still has a double standard?

258 Did you ever skip school before and if so what did you do instead?

259 Do you prefer water skiing or snow skiing?

260 Rate your table etiquette on a scale of 1-10 with 10 being outstanding and 1 being awful.

261 What is the most dangerous thing you have ever done?

262 Have you ever dated someone your parents didn't like?

263 Which do you prefer: pony tails or pig tails?

264 When have you ever made the first move?

265 Have you ever felt violated and if so in what way?

266 What are you superstitious about?

267 Where are you considered a regular at?

268 If you were a super hero what would your hero name be?

269 In the haste of your daily life, what are you not remembering?

270 What is the best thing about being you?

271 Do you think keeping animals in captivity is wrong?

272 When you find someone physically attractive, what's the first thing you notice?

273 What is the most cliché thing you have done in your life?

274 A wish you make again and again.

275 Have you ever been on a blind date?

276 Are you OCD about anything?

277 What happened to put you at your lowest low?

278 How do you get into the holiday spirit?

279 When people look you in the eyes, what do you hope they see?

280 For your wedding ceremony do you want it big and elaborate or small and intimate?

281 What is your favorite sci-fi film/program etc.?

282 Have you ever played a practical joke on anyone?

283 Do you have a crush right now? Who is it?

284 Have you ever helped someone through a trauma?

285 When you were a kid did you ever want to run away from home, if so why?

286 Do you have any lucky items, objects or traditions?

287 What has required you to put constant thought into it?

288 Do you have any questions you're just too scared or embarrassed to ask anyone about?

289 What is your favorite actress beginning with the letter J?

290 What was the hardest personal goal you've set for yourself?

291 Do you operate with the motto "it's my way or the highway" and if so does it work for you?

292 What's the last thing you've done that you were really proud of?

293 Would you win more money at *Jeopardy* or *Wheel of Fortune?*

294 What are you really lazy about?

295 Have you ever used the phrase "back in my time" to someone younger than you?

296 Which is better, Mario or Sonic?

297 What do you think one of the biggest cons about being famous would be?

298 Has anyone or anything specific ever made you feel inferior, if so what?

299 Do you think stay at home mothers should be paid a salary?

300 Do you sing to yourself?

301 How many of your friends would you trust with your life?

302 Do you have an image of something you'll never forget?

303 Have you ever demolished a wall or building?

304 What nickname have you been called you hate?

305 What great mystery do you want solved?

306 What is your favorite movie that won an Oscar?

307 Have you ever felt like you didn't fit in, if so where or when was it?

308 Do you throw bread for the ducks?

309 What brings a tear of joy to your eye?

310 What is the most important thing to carry with you all the time?

311 What are you unapologetic for?

312 Do you like your music loud or quiet for easy listening?

313 Has anything ever came to you in a vision or a dream?

314 If you were going to write a poem for the world, what would be the title and topic?

315 Have you ever done something heroic?

316 Have you ever maxed out your credit cards, on what?

317 What was the most obvious publicity stunt a celebrity ever pulled?

318 Do you like to describe what you see in the clouds?

319 What actor or actress do you think is too overrated?

320 What clothing designer do you LOVE?

321 Do your dreams ever tell you to do anything?

322 If you were going to poison someone, how would you do it?

323 What would you do in a world war situation?

324 Do you operate better at night or during the day?

325 Would you ever become a CIA agent, if so why?

326 What relationship or friendship do you regret ended?

327 Have you ever bought someone jewelry?

328 What was the worst hairstyle you ever had?

329 Who knows you better than anyone else?

330 Have you ever licked a battery?

331 What black and white movie is your favorite?

332 Do you play any games on your smartphone, if so what's your favorite?

333 Do you have any family heirlooms?

334 If you had to lose one of your 5 senses, which one would you give up?

335 Have you ever gone through a transformation, if so what did it involve?

336 Are you a role model for anyone in your life?

337 What book have you read multiple times?

338 Is there ever a good time to be confrontational?

339 What is your smartphone missing that you wish the designer would add?

340 Have you ever worn clothing with the labels/tags still attached?

341 What would you do if you came face to face with a huntsman spider?

342 What song is your favorite to slow dance to?

343 What character flaw of yours is both good and bad?

344 What is something you just have not been able to get over, even as time passes?

345 Have you ever gotten into trouble and couldn't get yourself out? Who did you ask for help?

346 Have you ever drawn on a sleeping person?

347 What do you want written on your tombstone?

348 Have you ever had a blessing in disguise, what was it?

349 Have you ever done anything that was forbidden?

350 Would you risk being late to work and fired in order to save an injured dog?

351 Have you ever seen a tornado up close?

352 Do you have a scar, if so how did you get it?

353 Has anyone ever approached you thinking you were someone else?

354 How tech savvy are you?

355 Have you ever dated two people at the same time?

356 Name 3 things about where you live that you find most beautiful?

357 If you were to remain single for the rest of your life do you think you could be happy?

358 What is the worst thing that could happen to you on a date?

359 Do you sleep with the TV or radio on?

360 What is your favorite thing to celebrate?

361 What are you candid about?

362 What lies do you often tell yourself?

363 Have you ever snuck in somewhere you shouldn't have been, if so where?

364 What dish or food usually served hot, and do you think is better cold?

365 What's the worst thing your parents ever said to you?

366 What was your worst nightmare?

367 Do you hold a grudge?

368 Have you ever crashed a wedding?

369 In your opinion what is the most toxic personality trait?

370 How are you quirky?

371 Is there something missing from your life?

372 Too much is never enough of...?

373 Which is better, violins or pianos?

374 Do you have a secret place you go to when you want to be alone?

375 What's the funniest thing you've ever done to your parents?

376 Did you or will you go to prom?

377 What's your favorite season?

378 Do you like energy drinks, if so what one is your favorite?

379 Could you fire someone you're friends with if it was your job?

380 How many people have you dated?

381 Who do you trust the most in your life?

382 Have you had a strange encounter that you can't explain or are scared to share?

383 What questions would you ask the older residents if you were visiting a nursing home?

384 Have you ever used the opposite sex restroom in an emergency, if not would you?

385 Do you read the labels on the food you buy or do you just buy what you like?

386 What is the craziest thing you've ever asked Siri?

387 In what way do you pamper yourself?

388 Do you like rap music, if so who is your favorite rapper?

389 If you were a psychologist, whom would you love to get on your couch for conversations

390 Would you prefer either a chauffeur or private chef for one month as a gift?

391 Best message you ever got in a fortune cookie.

392 What is the worst smell you have ever smelled?

393 What was the most memorable class you've ever taken in school or college?

394 Where is the scariest place you've ever been stuck or trapped?

395 In your opinion is anything lacking from music today?

396 What would you do if you made a mistake and somebody died?

397 Have you ever had an adventure in babysitting?

398 How shy are you when you meet new people?

399 What's your favorite accent?

400 How fast can you say the alphabet?

401 What was your favorite movie that was based on a book first?

402 What is your favorite thing to challenge people to?

403 Have you ever been or would you ever allow yourself to be hypnotized?

404 Where is your favorite place to take a nap?

405 What do you not take seriously enough?

406 How have you matured through the years?

407 Would you rather take a very long train ride or very long plane ride?

408 Do you have an area of your life that you are never satisfied with?

409 What do you think should be more regulated that is currently not?

410 How independent are you?

411 How much affection do you need to feel happy?

412 How would you do as a contestant on the reality game show *Survivor?*

413 What is your favorite author beginning with the letter R?

414 Who do you think you should stop spending time with?

415 Would you ever become a missionary?

416 Do you believe "it's a dog eat dog world" or do you have a different opinion?

417 What do you think about the vagabond lifestyle?

418 What 3 things would you leave in a time capsule for people to open in 50 years?

419 Would you raise your kids the way your parents raised you?

420 Does time heal all wounds or is that just a saying?

421 Do you ever watch movies with subtitles?

422 If you were in a band, what instrument/role would you play?

423 What is something you're doing you never thought you would do?

424 Working hours a week is too much for me.

425 What is the weirdest food combination craving you've ever had?

426 Have you ever had to make a big decision without enough information, if so what did you do?

427 If you were having lunch with the Queen of England, what would you talk to her about?

428 What reoccurring lie did you always tell your parents or teachers?

429 Do you still watch cartoons, if so which one/s?

430 Can you use chopsticks when you eat or have you tried?

431 What movie had the best special effects?

432 Have you ever been suspended from work or school, if so for what?

433 Have you ever cried at a movie?

434 Were you ever a girl scout/boy scout and if so what was the best thing you learned?

435 What do you wish had a delivery service that currently doesn't where you live?

436 What's the funniest Twitter handle you've ever heard?

437 What is your favorite clothing store?

438 Do you talk to yourself?

439 What grooming habit is essential to your daily life?

440 Out of your 5 senses, which is your strongest?

441 Would you ever launch an idea on Kickstarter?

442 Is your life more like the show *Friends* or *Married with Children*?

143 What is something you don't mind paying more money for?

144 Have you ever carried a torch for someone?

145 What has been your greatest sacrifice?

146 What do you think is more likely; Dracula or a werewolf?

147 If you had to teach something, what would you teach?

148 What's the funniest question you ever asked your parents when you were younger?

149 How good of a tipper are you when going out?

150 If you were going undercover for the CIA, what would you want your new cover story to be?

151 Have you ever eaten anything prepared by a celebrity chef?

152 How modern are you?

153 Are you a "fanatic" of anything or anyone?

154 What discovery have you recently made you feel is cutting edge?

155 Do you think cheerleaders are motivating or distracting at football games?

456 What was the last thing you dressed in costume as?

457 What is the funniest pet name you've ever heard?

458 Are you much of a thrill seeker?

459 Do you wake up with a smile?

460 What is your favorite piece of jewelry?

461 Have you ever entered a talent contest? What was your act?

462 Have you ever faked your way through something, what?

463 How long do you think you'll live?

464 If your significant other went to jail, would you wait for them to get out?

465 Have you ever turned into a detective checking up on someone or something?

466 If you could ever take a street sign or sign from anywhere, what sign do you want?

467 What's the longest you've gone without speaking to your best friend, why?

468 If you were famous would you want a statue or a building named after you?

469　How do you make the most of a bad situation?

470　What do you call your evening meal? Dinner or supper?

471　Is there such a thing as a bad challenge in your opinion?

472　Who do you always have to justify your actions to?

473　Have you ever walked out on dinner with someone?

474　Who's someone you'd like to trade places with for a day?

475　How open-minded are you?

476　Are you any good at burlap sack races?

477　What's the meanest thing you've said to someone?

478　Which would be impossible for you to give up for the rest of your life: soda or coffee?

479　How ambitious are you?

480　Do you think opposites attract?

481　What's the best thing about your life?

482 Have you ever needed an eye test?

483 Do you carry anything with you for self-defense when you leave your home?

484 If you could read minds, whose would you read first?

485 What weird behavior or habit did you have as a child that you ditched as you got older?

486 What do you consider both a blessing and a curse?

487 How do you get into your creative zone and do you have a creative ritual?

488 If you were entering a baking contest, what recipe would you make?

489 If you were out at dinner with no cash what would you do or say to get the bill paid?

490 What is an enemy to our existence or way of life?

491 Do you think Barbie is a negative role model for young girls?

492 If you saw a unicorn in the middle if the woods, what would you do?

493 When you have to study for a test, what is a proven successful method?

494 What's a common topic at your dinner table?

495 Who is your favorite dancer?

496 Did you do anything special for your 16th birthday, what?

497 If you wrote your will right now who would be the beneficiary?

498 What talent were you gifted, that comes natural?

499 Have you ever been disappointed by something you anticipated to be bigger than life?

500 If you could be an explorer, what would be your expedition?

501 What do you love about the internet?

502 Who was the last person to knock/ring at your door?

503 Where is your ideal place to raise kids or start a family?

504 Do you make choices on what's best for you or what's easiest?

505 Did you ever sneak out of your house after curfew without your parents knowing?

506 What topic do you always give your two cents on?

507 Do you prefer blue or black inked pens?

508 Do you read other people's body language and if so does it help?

509 What is your favorite "take out" place?

510 Have you ever lied your way out of a bad situation, what?

511 What do you always lose track of besides time?

512 What strange thing would you like to happen at your funeral to make people laugh?

513 What is your favorite pancake or waffle topping?

514 What is your most favorite decorative piece or artwork you own?

515 How much money would make you happy?

516 What famous person's memoire would you love to read?

517 Would you rather give your money or time to a charity?

518 When you die, do you want to be buried or cremated?

519 Are you a clean or messy person?

520 You're auctioning yourself off for charity, why would someone pay big dollars for you?

521 What do you think is the biggest sign of a weakness in a person?

522 What potential talents do you think you might have if you worked at them?

523 How could you expand on your creative abilities?

524 Have you ever owned a goldfish?

525 Have you ever tried online dating, why/why not?

526 If your life were a commercial, what would your commercial jingle say?

527 What do you love to do for "me time?"

528 If someone assigned you a random job to start, what's the worst career for you?

529 Do you do your utmost for the environment?

530 Do you say curse words, if so which one do you use the most?

531 Worst leader in history, in your opinion?

532 What is your biggest debt right now?

533 Would you ever consider living in Iceland?

534 What eats up most of your time that you'd like to change?

535 What do you feel connected to?

536 How blunt are you and what is the boldest thing you've said to someone?

537 What thing that you've made are you most proud of?

538 Do you like your significant other's friends, why or why not?

539 Have you ever felt like a hamster on a wheel never getting anywhere? Why?

540 Do you have a chip on your shoulder about something?

541 What is that one thing your friends or family never let you live down?

542 What word or phrase do you say too much?

543 How did your parents meet?

544 What was something that happened to you as a kid that still scares you today?

545 If you had to attend a military boot camp, rename it based on your current fitness level.

546 What is the quickest way to your heart?

547 Have you ever been scuba diving?

548 If you have to be handcuffed to someone for 24 hours, who would it be?

549 Give your funniest answer to: "why did the chicken cross the road?"

550 What have you read online recently that inspired you?

551 Compare your writing style to any published author.

552 Will you still celebrate your birthday the older you get?

553 What do you have a love/hate relationship with?

554 Where is your favorite place to meditate?

555 What do you think is the biggest violation of privacy?

556 What crime would you like to investigate?

557 When you were a kid did you ever ask Santa for anything, if so what?

558 Have you ever been kicked out of anything, if so what?

559 Who was your first crush?

560 Could you ever be a mortician if it paid really well and you needed a job?

561 Describe war in your opinion in just a few words.

562 How good is your willpower? Typically what do you use it for?

563 What is the most despicable thing about politics?

564 How many pairs of shoes do you own?

565 Have you ever walked out of a cinema before the film was done?

566 What makes you vulnerable?

567 A secret you've been wanting to share.

568 What is something you've gotten a second opinion on?

569 If you could collaborate on a rap with one rapper, who would it be?

570 What is the cleverest way you ever asked for someone's phone number?

571 What is your favorite smell/scent?

572 What is your favorite popcorn topping?

573 Have you ever ridden a mechanical bull, or would you?

574 Have you ever been in a submarine?

575 How do you march to the beat of your own drum?

576 Which song do you hate the most?

577 Where do you lack discipline in your life?

578 What is one thing you do you consider practical?

579 If you were in charge, what 3 items would you have in the office vending machine?

580 Do you trust people that don't look you in the eye?

581 Are you an introvert or extrovert?

582 Do you have in-laws, if so do you get along with them?

583 Do you act different around a certain person, if so who?

584 What does your typical breakfast look like?

585 Have you ever tried to change anybody, if so who?

586 How old do you feel?

587 If you were to get a tattoo tomorrow what would it be?

588 Do you have any family secrets?

589 What is your favorite activity or way to workout (even if it's a small amount)?

590 Who do you seek most for advice?

591 Would you work less and do more of the things you enjoy if it meant you had less money?

592 Do you think street smarts count for anything?

593 If you saw someone drop a $10 bill, would you keep it or try to return it?

594 If you could be a host for a day would you host a game show, award show or what?

595 Would you be open to preserving your body through cryogenics?

596 Do you like scary movies?

597 What is your most embarrassing moment in public?

598 How do you cheer up a friend?

99 What is the last thing you took a picture of?

00 How are you always or ever evolving, what specific thing do you do?

01 When you were in school who was your favorite essay or assignment about?

02 How important is physical fitness to you?

03 How close are you to your family?

04 If you broke down on the side of the road could you change your own tire without help?

05 Who or what has been your best teacher?

06 Do you support local businesses in your community, if so what's your favorite?

07 How sensitive are you?

08 Do you have a favorite uplifting self-help book that encourages you?

09 If you were asked to create a column like "Dear Abby" what would you call it?

10 Have you ever felt trapped, if so when?

11 Do you like comic books, if so what's your favorite?

612 What word do you have the hardest time spelling?

613 Have you ever played Sudoku, and on a scale of 1-10 (10=expert) how good are you?

614 What's your most expensive piece of clothing?

615 What's your favorite saying?

616 If you started your own podcast what would it be about and what's the title?

617 How impulsive are you and what are you most impulsive with?

618 Have you ever overheard someone saying something negative about you? What was it

619 What makes you feel like a kid again?

620 If you were entering a world like *Star Wars* would you be a Jedi or Sith?

621 The biggest jerk you've ever met.

622 What is the most serious issue facing the planet right now?

623 What wild animal deserves our protection?

624 Is there something in life you'd never give up for anyone?

525 What restores your faith in humanity?

526 Are you afraid of dying, if so how do you cope?

527 If you were joining the *Star Wars* cast as a Jedi, what would be your Jedi name?

528 Are you psychic in any way?

529 What is your favorite breed of dog?

530 What is your preferred playing piece in *Monopoly?*

531 What was the one most important thing you learned from your parents?

532 What is the biggest piece of wisdom you think our elders can offer?

533 Have you ever given someone bad advice? If so what did you say?

534 Are you a bad loser or a good sport?

535 What quality or trait do you possess that could make people see you as a warrior?

536 What is one thing people buy that you think is a total waste of money?

537 What was your last big achievement?

638 Did you apply to or win any scholarships, if so what kind?

639 What keeps you balanced in life and work?

640 If you could steal one thing without consequence what would it be?

641 Are you reliable?

642 If you were on death row what would be your last meal?

643 What can people count on you for?

644 Are you any good at giving massages?

645 How many times have you had your heart broken?

646 If you were going to be a famous artist, who would be your muse?

647 Do you try to learn something new every day?

648 What is your favorite party game?

649 Do you think smiles are contagious and do you smile more than not?

650 What could someone use to bribe you?

551 What is your idea of relaxing?

552 Are you financially responsible or do you still have problems managing money?

553 Have you ever attended a book reading, if so what book?

554 Do you have an incident from college you wish you could erase?

555 The biggest misconception.

656 What is your favorite joke?

657 Where can you find the best view in your city?

658 What is the longest book you've ever read?

659 What do you hate about the internet?

660 Do you consider yourself a nature lover?

661 Describe one undeniable fact about yourself.

662 What's the toughest decision you've made this year?

663 What is your favorite fruit?

664 Do you ever laugh at things you shouldn't?

665 What's the most expensive thing you own?

666 What do you think airlines should offer on flights that they currently do not?

667 What is meaningful to you?

668 Do you have any music on vinyl or cassettes?

669 What gives you the creeps?

670 Do you think it's good to take it one day at a time?

671 Do you think flying is safe or do you have reservations?

672 What's the biggest lie you once believed was true?

673 What was the hardest goodbye you ever had?

674 Do you know how many kids you want if any and do you want boys or girls?

675 What is one thing in your life you can't make a decision on?

676 Have you ever ridden a camel?

577 What gets you excited about life?

578 Do you have a favorite thing you do for "girls/guys night out"?

579 Have you ever tried to be something you weren't, if so what?

580 Would you still buy a desktop computer or do you consider them obsolete?

681 Do you believe in aliens?

682 What is the last meal you cooked for someone?

683 What one thing does your mom do that makes you laugh?

684 How do you feel about redheads?

685 What is the smartest investment you've ever made?

686 What TV sitcom (past or present) best represents your family?

687 Do you think schools need more physical activities versus activities to resolve conflict?

688 What is something you hate but wished you loved?

689 What is one thing you failed at many times but kept trying until you finally succeeded?

690 What is the main thing that influences your decisions?

691 If you were going to write a children's book, what would the story be about?

692 What was the first responsibility your parents gave you as a kid?

693 What stood out in one of your most memorable dreams?

694 What would you do if someone proposed to you tomorrow?

695 What magazine would you like to be on the cover of?

696 What do you think you'd be good at selling?

697 What is the biggest high pressure situation you've ever found yourself in?

698 What is your weirdest trait?

799 Can you name all 50 state capitals in the U.S.?

700 If you invented a monster what would you call it and what would it look like?

701 What's the most recent self-discovery you uncovered?

702 What do you like to eat with your sandwich (soup, fries, or something else)?

703 What is your favorite word beginning with the letter X?

704 What's the most embarrassing thing your parents did to you as a kid?

705 Have you ever colored in an adult coloring book, did you like it?

706 What is one thing college freshmen should be prepared for?

707 Have you ever been in a newspaper?

708 What is your favorite trivia game?

709 Name one thing you could do to become a modern day Robin Hood?

710 Has anyone ever said "I love you" and you couldn't say it back?

711 What was some of the best news you ever received?

712 Who is the most philanthropic person you know and who do they give to?

713 Is your bellybutton an innie or outie?

714 Do you believe in one best friend or just friends?

715 What vegetable do you hate?

716 Have you ever burned a bridge on purpose and how do you feel about that now?

717 What law do you think should be more of a personal choice, instead of a law?

718 Do you have a favorite YouTube channel, what is it?

719 The most annoying bill you have to pay?

720 Your secret obsession.

721 What is the scariest insect you can think of?

722 What hobby or activity do you think is totally boring that other people enjoy?

723 What one thing could you easily live without?

724 Do you think there is life after death?

725 A memory you think of often.

726 What is one thing if you ever lost it would devastate you?

727 Do you believe in "don't let the sun set on your anger," meaning don't go to bed angry?

728 Are you a convincing liar or can people see through you?

729 What is something children of today are not doing enough of?

730 What has been the worst decision you've made in your life so far?

731 Coke or Pepsi?

732 How good are you at fixing things and what specifically are you handy at?

733 What was the last social faux pas you made?

734 What do you think there is a "war on" in today's society?

735 What celebrity makes you want to scream (in a bad way)?

736 Do you have an expansive vocabulary?

737 If you had to create chapters in your diary or journal, name 3 chapters.

738 What do you do when you want to get out of your own head?

739 What's the funniest movie you've ever seen?

740 Have you ever been called a troublemaker, if so by who?

741 What is something in life you really have an appreciation for that most people don't?

742 Do you give your opinion and feedback on surveys?

743 Have you ever been in a tug of war? Did you win?

744 What do you hate the monotony of?

745 What is your favorite flower?

746 Do you think a stay at home mom works just as hard as a career woman?

747 Are you a lover or a fighter?

748 If you were a stand-up comedian, who do you know would give you the most material?

749 What or who has made the biggest impression on your life in the last year?

750 Do you bite your nails?

751 How do you feel about nepotism?

752 How much would it cost to buy your love?

753 How often do you laugh?

754 What instrument do you know how to play?

755 If you were a wrestler what would your stage name and special move be?

756 Use one word to describe your confidence level.

757 What's the best Valentine's Day gift you've ever given/received?

758 Have you ever had a stuffed toy important to you, if so what kind and what was its name?

759 Who was your very first celebrity crush on?

760 Do you think any kind of afterlife exists?

761 What is your favorite chick flick or romcom movie?

762 What is one thing you won't admit to yourself?

763 What question do you want to ask the universe?

764 Have you ever been somewhere you thought was haunted, if so where?

765 What has made you feel completely validated?

766 Have you ever done something and had no idea why you did it, what was it?

767 Do you stick to conventional fashion or like to be original?

768 There were two nature channel shows on mermaids. Do you think they could exist?

769 Do you give money to homeless people you see on the street?

770 What is your least favorite personality trait you like about yourself?

771 What have you considered interning for?

772 What is your favorite way to spend a Sunday?

773 If you could have a child with a famous person, who would it be and for what reason?

774 Do you think the guy should always pay? What about on the first date?

775 What novel would you love to be transported into to live out your days?

776 What do you think about the "tiny house" craze and is it for you?

777 When you meet a new person do you like to talk about yourself or prefer to let them talk?

778 What is the coolest nickname you've ever heard for someone?

779 How good are you at trivia questions and what trivia subject would you excel at?

780 Would you kill an innocent person if you thought it might mean saving a dozen others?

781 If a genie offered you three wishes, what would you wish for (not more wishes)?

782 What housework/chore do you absolutely refuse to do?

783 Name something you had a close call with?

784 If you could live one week with an uncivilized tribe to learn their ways, would you?

785 What one thing are you worried will never change for you?

786 How do you resolve conflict?

787 If you were going to write an essay about your life what would your essay be called?

788 Do you think there should be a salary cap for actors in movies?

789 Do you have a favorite furniture designer, if so who?

790 What is your favorite outfit?

791 What is your point of no return?

792 Are you a godparent to a child, if so whose?

793 What did you think was stupid until you tried it?

794 Who is the most interesting person you've ever met?

795 Would you try to eat vegan for a week or longer?

796 Would you say you're easy to get along with?

797 What is the most expensive thing you've ever broken?

798 Have you ever got majorly lost trying to get somewhere?

799 Could you ever go out with someone just because they're rich?

800 Do you know what an Arnold Palmer is and if so do you like it?

801 What is the fastest way to get you bored?

802 What is the bane of your existence?

803 What birthday do you feel is more of a landmark: 16th, 18th or 21st?

804 What is your favorite nursery rhyme?

805 Do you trust your coworkers?

806 What scares you the most about getting older?

07 Is there any one product that has changed your life in a good way?

08 Is there any experience you've not had that you regret not having yet?

09 What is your favorite Broadway show or one you really want to see?

10 What book do you think should be mandatory for everyone on the planet to read?

11 What do you think most people take for granted?

12 What do people take for granted that really bugs you?

13 Would you say you are a good or bad influence to others?

14 What is the most beautiful city in the world?

15 What is your favorite idiom?

16 If you were going on *Shark Tank* to pitch an idea, whom would you want to work with?

17 Have you made an impact on anyone's life, if so who?

18 What is your favorite band beginning with the letter Q?

19 What bad habits do you think kids pick up from their parents?

820 Have you ever talked in your sleep and if not what would you be afraid to say?

821 What random act of kindness should be done every day?

822 Do you spend too much time pleasing others at a detriment to yourself?

823 Do you always wear identical socks?

824 Do you have any allergies, specifically to food that are serious?

825 What is the main thing you've always had second thoughts about?

826 What two celebrities would make the craziest couple you could think of?

827 Who do you think in general is smarter, men or women?

828 What is one thing you know about your mom or dad that they don't know you know?

829 What are a few things you need to cleanse from your life?

830 What is the craziest craving you ever had?

831 How organized are you?

832 Do you think cigarette smoking should be illegal?

333 Have you ever walked out of a restaurant or bar without paying your bill, if so why?

334 What's the best thing about being a part of your family?

335 Have you ever been a big brother or sister to a less fortunate youth, would you?

336 How do you feel about your family?

337 When you were a kid did you have any posters on your wall, if so of what?

338 What is something you're teased about relentlessly?

339 What is the biggest city you've ever been to?

340 What do you think the most romantic proposal looks like?

341 What is your favorite thing to BBQ?

342 Do desperate times call for desperate measures?

343 What are you too hard on yourself about?

344 Would you fight for the one you love or would you just let them go?

345 Do you prefer movies with or without special effects?

846 What is the nicest thing a stranger has ever done for you?

847 If you were a woman would you propose to a man? If you were a man would you accept it?

848 Where would you never live?

849 What would be the best exotic pet?

850 Is there a food you loved as a kid but hate as an adult?

851 Have you ever rescued an animal, if so did you keep it or take it to a shelter?

852 Do you have a favorite news anchor, if so who?

853 What is your favorite metaphor?

854 Would you ever set up a nanny cam to spy on someone watching your kids?

855 How many back up plans do you make for your original plan?

856 How do you feel about people wearing animal furs and animal skinned shoes?

857 Would you ever date someone much older or younger than you, and which?

858 What do you do to cool down when it's hot out?

359 What do most people consider a weakness that you actually find strength in?

360 Have you done something you worry could come back to haunt you, what?

361 Should graduating high school be mandatory?

362 What is the most important thing in your life right now?

363 What are you hypocritical about?

364 Do you like racing events like cars, horse or dog and if so what is your favorite?

365 Do you watch football, if so do you have any special "game day" rituals?

366 What animal do you think is jaw dropping beautiful?

367 How often do you self-reflect?

368 What would you ask King Henry VIII if you could have dinner with him?

369 Do you like to cuddle?

370 Have you ever danced in the rain?

371 Who or what challenges you?

872 What song makes you sad the moment you hear it?

873 What is the closest thing to your superpower?

874 What is the scariest thing you've ever done?

875 What is your favorite film beginning with the letter L?

876 In any of your relationships what was one of the hardest challenges you faced?

877 Biggest risk you've ever taken.

878 If you were a stranger looking at your life from the outside in, would it inspire you?

879 What major scientific advancement do you predict will be released in the next 20 years?

880 Do you let other people's negativity effect you?

881 What issue has ever divided your family or a specific relationship?

882 Have you ever shoved things in the closet to make your room look clean?

883 What type of journalist would you be?

884 Have you ever starred in an amateur or professional video?

385 Have you ever gotten lost in a maze?

386 Have you ever sworn at an authority figure?

387 Do you think people are basically bad or basically good?

388 Have you ever shamed anyone and if so what for?

389 If you wrote an autobiography what would your book be called?

390 What is one thing you hope to do before you die?

391 Do you prefer to wash up in the mornings or evenings?

392 What was a game changer in your life?

393 Are you a realist or do you like to lose touch with reality sometimes?

394 What fashion style would you like to bring back?

395 What is the biggest obstacle you've had to overcome?

396 When you think about the future what one word comes to mind?

397 Who do you think has the best smile?

898 Who is your favorite TV talk show host past or present?

899 What is one thing you hate about computers?

900 Have you ever Googled yourself or a family member?

901 What brand or product do you buy because you feel it's trustworthy?

902 If you discovered a new species of dinosaur what would you call it?

903 How many times a day do you check your Facebook?

904 Do you think regular (not cable) TV shows has too much inappropriate content?

905 If you designed your own sushi roll what would be in it and its name?

906 If you could have any feature from an animal what would you want?

907 Who have you learned the most from?

908 Finish this sentence as if it were your life: "It was a dark and stormy night…"

909 If you were a fashion designer, what style of clothing or accessories would you design?

910 What do you think of non-profit organizations that pay their CEOs using donated funds?

911 What's the grossest thing you've ever seen someone do in public?

912 What is the first thing people usually notice about you?

913 Do you believe in miracles, have you had one?

914 The oddest job you ever took to earn a buck?

915 In past publicized criminal cases, who was "not guilty" that you would have convicted?

916 What do you love on your burger or veggie burger?

917 Did you ever fail a subject in school, if so what class?

918 What is something constant in your life?

919 Have you ever conducted an experiment that went awry, if so what?

920 Name your alter ego.

921 Where is somewhere you really want to visit but you worry you won't eat the food?

922 What benefit do you think employees should get that most companies don't offer?

923 If you were on the run from law enforcement what country would you flee to?

924 Have you ever made someone cry?

925 Can you solve a Rubik's cube?

926 What is the most artistic thing you've ever done?

927 What would your friends say about you?

928 What was the hardest test you've ever taken and did you have to take it over?

929 What blood type do you have?

930 What is your favorite game beginning with the letter N?

931 When was the last time you felt lucky?

932 Have you ever been bitten or attacked by an animal, if so what and why?

933 What movie ending really frustrated you? And how would you change it?

934 Have you ever had anything waxed, if so what?

935 What is one thing you'll never be associated with?

936 What makes someone a bad kisser in your opinion?

937 What keeps you going?

938 What topic would you be totally clueless about if it came up in a conversation?

939 Do you have a piggy bank?

940 What type of people scare you?

941 What is your favorite spa service (massage, facial, etc....)?

942 How do you handle two-faced people?

943 Who would call you their biggest cheerleader?

944 Do you have a specific personality trait or something specific that makes you popular?

945 If you could be reincarnated as an animal, what animal would you choose?

946 Do you think the glass ceiling still exists or has it finally been broken?

947 What do you want to do when you retire?

948 What is something that intrigues you and scares you at the same time?

949 Do you watch any nature programs, if so which ones?

950 Are you still close with any of your early childhood friends, and who?

951 How do you deal with shallow people?

952 What was your happiest dream about?

953 Who is your favorite superhero?

954 What compulsions do you have?

955 Can you build a house of cards?

956 Do you often have a tune in your head you can't name?

957 Has someone ever been promoted over you who you felt was not qualified for the job?

958 What is the definition of a soul to you in a few words?

959 If you could go on an adventure tomorrow, what adventure would you choose?

960 How do you feel about fracking in a few words?

961 Would you rather swim in a pool or the ocean?

962 Are you possessive, if so how much?

963 What are your top 3 bloggers/blog sites to read?

964 What's the most sensible thing you've ever heard someone say?

065 If you were a villain or criminal mastermind what would be your calling card?

066 Are you a good aim with a rubber band?

067 What was your parents' greatest sacrifice?

068 Do you think in this day and age investing in the stock market is wise?

069 Have you ever been electrocuted?

070 What color annoys you when you see it?

071 If you were a chicken, why would you cross the road?

072 What is/was the best thing about being in a relationship?

073 What keeps you optimistic?

074 Have you ever turned something valuable someone lost in or kept it?

075 What's one chore or task you love doing?

076 If you could create a fantasy land what is one thing it would have in it?

077 What tests your patience?

078 If you could talk to one species of animal what would it be?

979 Do you take the time to listen to what others have to say?

980 What is your most favorite way to receive affection?

981 If a waiter spilled a drink on you but it was an accident, would you still tip?

982 What are you allergic to?

983 What is one thing you wish you could change about your family?

984 Are you a positive person?

985 What is your favorite song beginning with the letter I?

986 Have you ever read a tabloid, if so which one?

987 Have you ever been fired and if so from where?

988 Have you ever test driven a car you couldn't afford, if so what car?

989 Have you ever staged an intervention and for what?

990 Many people read electronic books. Do you think that takes away from the experience?

991 Have you ever invented a fairly unique meal or drink?

992 Have you ever gotten back into a relationship with an ex, if so did it work out?

993 What is your favorite dessert?

994 Are you more of a leader or follower?

995 What is harmonious in your life?

996 What keeps you busy most days?

997 Do you think all is fair in love and war?

998 What's the most radical thing you've done appearance wise?

999 How do you feel about growing older?

1000 What is the meaning of life?

1001 What celebrity's crib would you love to take a tour of?

1002 How can you live with more intention?

1003 Do you brood about anything?

1004 Do you prefer to wear shoes or go barefoot, why?

1005 What is the most expensive gift you've ever bought for someone?

1006 Have you ever run for an election, if so what was your campaign?

1007 What has been the best decision you've made in your life so far?

1008 Have you ever been attracted to someone your best friend was dating?

1009 What causes you deep emotional pain when you think about it?

1010 What do you consider is the most important piece of furniture in a house?

1011 What "new beginning" are you most looking forward to?

1012 If you personalize your car's license plate, what would the plate say?

1013 What is your favorite mix of salty and sweet?

1014 If your parents hated your partner you loved, would you listen to them and break it off?

1015 Have you ever practiced origami?

1016 Do you believe in ghosts?

1017 If you ruled your own country, who would you get to write your national anthem?

1018 Are you a giver or a receiver?

1019 Something you always over exaggerate.

1020 Best advice you've ever been given?

1021 What was your favorite bedtime story as a child?

1022 Do you have a propensity for anything?

1023 Have you ever been wheelbarrow racing?

1024 If you were a going to be a wedding singer, what would your stage name be?

1025 What is your favorite kind of puzzle?

1026 Do you believe everyone deserves a second chance?

1027 What is your favorite cartoon character beginning with the letter W?

1028 What is the most enjoyable thing your family has done with you?

1029 Have you ever been alienated, if so from what?

1030 Something you keep close to your heart.

1031 Have you ever built a snowman?

1032 You're falling through the rabbit hole, what's on the other side?

1033 Have you ever felt like you were being stalked and if so how?

1034 What food do you love but gives you a bad reaction or is too hard for you to eat?

1035 Do prefer to live in the heart of the city or out in the peaceful countryside?

1036 What do you think is the scariest thing about becoming a parent?

1037 If you could try out a job for a day just to see if you like it, what job would you choose

1038 What one thing could you do a little better every day?

1039 Have you ever hit rock bottom?

1040 Who is your biggest supporter?

1041 If a reality TV show were based around your life what would it be called?

1042 Are you a hat person?

1043 Do you like your age?

1044 What particular field of study were you really interested in, but decided not to pursue

1045 What industry do you think is most harmful to the planet or environment?

1046 What do you like on your toast or biscuit?

1047 Would you allow a foreign exchange student to live in your house?

1048 Have your parents told you something as an adult they kept from you as a child?

1049 *Harry Potter* or *Lord of the Rings*, which story is best to you?

1050 What makes you feel unsafe?

1051 Do you consider yourself to be high maintenance?

1052 What do you find ethereal?

1053 What is the kindest thing you've done for a stranger?

1054 How many countries have you visited?

1055 Would you ever let your parents pick out a partner for you?

1056 What movie or book ending really left you hanging to the point of anger?

1057 What distracts you the most every day?

1058 Given the chance would you work from home or do you love working with others?

1059 Have you ever judged a book by its cover?

1060 What 3 wishes would you grant the world?

1061 Have you ever lied to get a promotion or anything else?

1062 If you had to dedicate the rest of your life to a cause, what would that be?

1063 Can you stand on your hands unassisted?

1064 Are you being true to yourself?

1065 Can you easily move forward after a hurt?

1066 What one trait do you have that will make you a terrible boss?

1067 What animal do you think should be added to the endangered species list?

1068 What do you do when you get a "gut" feeling about something?

1069 What was the last thing to make you feel happy?

1070 Do you think it's important for a wife to take her husband's last name?

1071 What's your biggest challenge in the mornings?

1072 What is the next biggest step in your life?

1073 Have you ever spied on anyone via social media?

1074 What games do people play that drive you crazy or get on your nerves?

1075 Do you share a bond with someone, if so who?

1076 What makes technology useful to you?

1077 How old were you when you last went trick or treating?

1078 Have you ever played golf?

1079 Would you rather be a jack-of-all trades or master of one?

1080 Do you prefer male or female singers' voices?

1081 Have you tried something completely unorthodox that was supposed to be healthy?

1082 Have you ever been in a position of authority?

1083 Do you celebrate the things you have?

1084 What or who keeps you grounded?

1085 Have you ever been sledding?

1086 In your opinion who was the worst President of the United States?

1087 Are you familiar with *Robert's Rules of Order* and if so do you agree?

1088 Did anyone in your family have a "home remedy" and what did it cure?

1089 If you were playing a game of truth or dare, what dare would you be afraid to attempt?

1090 How good is your balance and could you balance on a tightrope with practice?

1091 What temptation can you not resist?

1092 When you get stuck on bed rest what do you do to pass time?

1093 Do you move a lot?

1094 What is your special song?

1095 How sociable are you in new group settings?

1096 What's your favorite time of the year?

1097 Who is the best playwright in your opinion?

1098 What is your favorite way to start your day?

1099 What is the worst name you've ever called anyone?

1100 If you had to take superhero sides are you Marvel or DC?

1101 Do you believe in fate or that a person shapes their own destiny?

1102 When getting ready for a party, what takes you forever?

1103 Do you still have feelings for an ex that have never gone away?

1104 Are you ok going out alone or do you prefer to have company?

1105 Have you ever been bobbing for apples?

1106 What is the longest road trip you've ever done in a car so far, where'd you go?

1107 What have been accused of being irrational about?

1108 Do you need to write down things to remember them?

1109 Have you ever sailed a boat?

1110 Who is the most drama filled person you know, and what do they do?

1111 Have you ever had a run in with the law and if so what for?

1112 If ketchup wasn't available, what would you like to dip your fries in?

1113 Are you good at owning your mistakes?

1114 What do you think about the sound of your voice and what do you think you sound like?

1115 What was the last book you read, sum it up in one word?

1116 What question are you too embarrassed to ask anyone?

1117 What is your favorite type of tree?

1118 What game show do you think you'd win the most money on?

1119 What is your biggest weakness?

1120 How do you personally feel about gambling of any kind?

1121 Have you ever given blood?

1122 What do you usually have to improvise on?

1123 What monument do you think should not have been erected?

1124 Have you ever put a part of your life on hold, what part?

1125 Pick a title of a novel to describe your love life.

1126 Do you have a green thumb?

1127 Who is your favorite comedian?

1128 Would you ever consider living on an island, why or why not?

1129 If there were aliens in the universe, what would you say to them?

1130 Do you believe change is a good thing?

1131 If a tree falls in the forest and there's no one around to hear it does it make a sound?

1132 Name one infamous person you actually like and want to hang out with.

1133 What gift would be awkward to receive from your boss?

1134 Have you ever walked a tightrope?

1135 Do you usually say what's on your mind or do you hold back?

1136 What is something you just can't relate to?

1137 Your biggest "what if?"

1138 What is a growing concern of yours?

1139 Has someone ever given you a second chance, if so how?

1140 What flavor icecream do you hate?

1141 What do you think all kindergarten students should learn?

1142 Do you have a kind of un-special talent you're really good at?

1143 What was the most generous act of your life so far?

1144 Are your expectations of other people realistic or too high?

1145 When have you ever really scared yourself?

1146 If you had to be handcuffed to someone for 24 hours, who would it be?

1147 What is your perfect weekend getaway?

1148 Where are your ancestors from?

1149 Who was the last person you hand wrote a letter to?

1150 You've just been invited to tour the White House, what are you most looking forward to?

1151 Do you ever feel blue and if so what triggers it?

1152 What 3 things would you never do on vacation?

1153 Do you keep a journal and does it help you?

1154 Has your ego ever gotten in the way of work or a relationship?

1155 Would you ever consider adopting a child?

1156 Who would you want to spend the last day of your life with?

1157 Have you ever felt discriminated against, if so how?

1158 What's the longest you've ever grown your hair?

1159 What instance did you not take "no" for an answer?

1160 Do you like other people buying you clothes?

161 What is usually your first thought when you wake up?

162 What is the earliest memory you have of your childhood?

163 Has your life ever flashed before your eyes, if so what made it happen?

164 Would you rather ask permission or apologize later?

165 Do you have any phobias?

166 If you had the opportunity to get a message across to a large group, what would it be?

167 What is your favorite scent of candle or room spray?

168 What is the most important thing you ever forgot?

169 Where is the strangest place you've ever fallen asleep?

170 Who can you impersonate really well?

171 What one skill or trait do you feel is imperative to be successful?

172 If your local newspaper were running a story on your life, what would the headline say?

173 What makes a party boring?

174 Would you ever raise your own chickens for fresh eggs?

1175 What is your favorite part of the day?

1176 Do you have a Swiss army knife?

1177 If you were to enter food-eating contest what would you want the food to be?

1178 What is one thing you wish you had the money to pay someone to do for you?

1179 Have you ever been pulled over by a cop, if so what were you doing?

1180 Is there a role in your life you feel very honored to have?

1181 In one sentence, how would you describe your relationship with your mother?

1182 Where and who was your first live concert?

1183 How would you explain your basic life philosophy?

1184 How would you describe your attention to detail?

1185 Do you think laughing at someone else's misfortune is wrong?

1186 What was the hardest thing you ever had to make peace with?

1187 What used to scare you as a child?

1188 Would you risk your life to save someone, if so who?

189 What is something most people get wrong about you when they meet you?

190 What opportunity do you wish you would have taken?

191 Have you ever gotten food poisoning and if so what food gave it to you?

192 What was your first job?

193 What is your favorite part of the weekend?

194 What is your favorite bedtime story?

195 Where have you always wanted to have a birthday party?

196 What is something that should be forbidden but is tolerated?

197 Have you ever been bungee jumping? If not, do you want to?

198 What is your favorite restaurant?

199 In your opinion what's the best thing since sliced bread?

1200 What's your favorite website?

1201 Do you prefer baths or showers?

1202 What traffic laws or moving violations do you always seem to break?

1203 What's the biggest thing you need to improve?

1204 Are you comfortable learning new things, what was the last new thing you learned?

1205 What is your favorite mystery series?

1206 Describe what you want your retirement to feel like in one word?

1207 What do you and your friends do when you hang out?

1208 Are you supportive of a friend even if you don't agree with what they are doing?

1209 What is your favorite way to stay in shape?

1210 Who do you think is the most credible philosopher?

1211 Are you neat or messy?

1212 Do you think happiness is a choice?

1213 What has been your biggest sacrifice?

1214 What famous celebrity chef would you want to cater your dinner party?

1215 What is the longest movie you've ever watched?

1216 Do you like to travel?

217 If you decide to get cremated, where would you want your ashes spread?

218 Who do you think you inspire?

219 If someone asked you to give them a random piece of advice, what would you say?

220 If there is hair in your food at a restaurant, what would you say?

221 Describe your mood right now using one word.

222 Does looking on the bright side help you?

223 What is your first proper memory?

224 What do you do if people are nosing into your business?

225 Do you believe in taking leaps of faith?

226 Who told you the best stories when you were a kid?

227 If you were a flower, what type would you be?

228 Do you have an unresolved ongoing family issue?

229 If you had to create a children's book about an animal, what would your book be about?

230 What sound relaxes you?

1231 Do you think it's important for a couple getting married to share the same beliefs?

1232 What have you ever done out of spite?

1233 If you ever became a writer, what would be your writer's pseudonym?

1234 If you had to describe yourself as a flavor, what would it be?

1235 What is something too hard for you to imagine?

1236 Have you ever rescued anyone or anything?

1237 Do you think medical science is ahead of the times or behind?

1238 What is something you came close to giving up on?

1239 Would you rather trade some intelligence for looks or looks for intelligence?

1240 When do you function at your best?

1241 What is the first thing you reach for when you need comforting?

1242 Have you ever called in sick to work to do something more exciting, what was it?

1243 Have you ever had to rehearse anything, if so what?

1244 Do you watch any of the singing competitions, if so who is your favorite contestant?

245 If you could invent brand new baby names what would they be?

246 What emotion is your least favorite and the one you are not in touch with?

247 What celebrity do you think is a positive role model for kids today?

248 Which do you like more: a really good book or a great movie?

249 If you joined the circus what kind of performer would you be?

250 If you participated tomorrow, could you win a spelling bee?

251 What should wedding vows be about?

252 Where was the last place you traveled to?

253 Do you think there is life on other planets?

254 Are you a trendsetter?

255 Do you believe in destiny, fate or free will?

256 If you could have anything named after you, what would you want it to be?

257 What horror fiction character scares you the most?

258 Do you think there is any merit to following feng shui in your home?

1259 What was the brand of your first ever cell phone?

1260 What are your 3 favorite internet sites?

1261 Do you have a favorite pair of blue jeans? Describe them.

1262 What is standing between you and one of your biggest dreams?

1263 What profession do you respect?

1264 Have you ever been the recipient of a practical joke?

1265 Have you ever ate something you've dropped on the floor, if so what?

1266 Would you consider being an Uber driver if you needed to make extra money?

1267 How do you know when you're in love, what is the main sign?

1268 Have you ever gotten anything autographed, if so by who and what was it?

1269 Do you prefer Walmart or Target?

1270 What do you long for?

1271 If you could be a personal assistant to anyone, who would it be?

1272 What is the most important thing you can do to improve yourself?

1273 Do you think society has become too PC (politically correct)?

1274 What tragic love story do you relate to?

1275 Has your intuition or "gut" served you well?

1276 What's the longest you've ever waited in line for something and what was it?

1277 Who is your favorite model?

1278 What have you done that is out of character for you?

1279 Would you rather get a gift card or a gift that shows the person shopped for you?

1280 Who is the most visionary person in your life and how do they inspire you?

1281 How do you handle a betrayal?

1282 What do you feel strong enough about to protest?

1283 What's the biggest blooper you've never lived down?

1284 If you owned a restaurant what kind of food would you want to serve?

1285 What will we find if we look in the bottom of your closet today?

1286 What kind of car did you learn how to drive on?

1287 Have you ever had to go to court or testify and if so what for?

1288 Are you more worried about doing things right, or doing the right things?

1289 What is the worst type of case for you to be on a jury where you would not be impartial?

1290 Do you believe in the term "Mother knows best"?

1291 Who is your favorite movie action hero?

1292 What is one thing you can get in your hometown that you can't get anywhere else?

1293 How important are looks in someone you're in a relationship with?

1294 What freedom do you feel is not really free anymore?

1295 What are you most thankful for?

1296 Do you have any favorite radio talk shows or talk radio programs that don't play music?

1297 What was the last book you read?

1298 What is your favorite online store?

1299 What band would you love to tour with and be a roadie for?

1300 If you were to throw a message in a bottle into the ocean, what would it say?

1301 What is your favorite non-alcoholic drink?

1302 What makes you feel rested and refreshed?

1303 If you could cast a spell on someone what spell would you cast and on who?

1304 What 3 songs will always be found at the top of your playlist?

1305 Do you keep a budget?

1306 What is the craziest thing you've ever done for someone?

1307 What is one thing you know about your family history you're proud of?

1308 What do you wait for discount sales to buy?

1309 What is priceless to you?

1310 What one thing in particular makes you feel good about yourself?

1311 Do you believe in karma?

1312 Have you ever been canoeing/kayaking?

1313 What do you think should require a mental health check before people are allowed to do?

1314 What do you like to put gravy on?

1315 What was the funniest joke you ever heard about?

1316 Who depends on you the most?

1317 Do you prefer sporty or academic members of the opposite sex?

1318 Are you in favor of the death penalty?

1319 Do you have to experience something to fully understand it?

1320 Has anyone in your family ever served in the military?

1321 Do you think you could ever be a firefighter, why/why not?

1322 Finish the next line in your style: Roses are red, violets are blue…

1323 What embarrasses you instantly?

1324 What do you think there should be stiffer penalties for?

1325 Do you follow what your friends do with trends or are you your own trendsetter?

1326 Do you often read your horoscope?

1327 Do you have any scars?

1328 Are you more like your mom or your dad?

1329 Do you think athletes and actors are overpaid?

1330 If you were ruler of your own country what would you call it and what would be your title?

1331 Are you a daredevil?

1332 What current event are you tired of hearing about?

1333 Have you ever felt like something was missing in your life, if so do you know what it was?

1334 Do you think you could beat a lie detector test?

1335 Have you ever received a harsher punishment than you deserved for something you did?

1336 What song on your playlist gets played the most?

1337 Have you ever ridden on a train or subway and what did you like about it?

1338 Did you create a checklist for your ideal spouse, if so what were two things you wanted?

1339 Have you ever let your mom or significant other fight a battle for you?

1340 Has one of your biggest fears ever come true?

1341 Is there anything about the opposite sex you just don't understand or comprehend?

1342 What is one old thing in your life you've had since your youth, you just can't throw away?

1343 What common pitfalls do you find yourself dealing with in your work life?

1344 Do you tend to follow your heart or your head?

1345 What celebrity or TV show in your opinion set a bad example for youth today?

1346 How do you feel about jazz music, if you like it who is your favorite?

1347 Have you ever been diagnosed with something that's challenged you, if so what?

1348 What is your favorite precious stone?

1349 If you had your perfect dream house, what kind of tree/s would you want in your yard?

1350 Describe your "poker face."

1351 If happiness were the national currency, what kind of work would make you rich?

1352 Do you keep up with current events, why or why not?

1353 Did you ever have a mean nickname that kids called you, one you didn't like?

1354 What childhood dreams have you neglected?

1355 Do you ever compare your life to anyone else's, if so who?

1356 What's the craziest thing you've done in a car?

1357 What do you think should be censored?

1358 Are you related to anyone famous or historical, if so who?

1359 Would you ever donate a kidney to anyone, and who?

1360 How do you encourage yourself when you go through hard times?

1361 How are you different from most people?

1362 Have you ever fired a gun?

1363 What is the main quality you think makes a great parent?

1364 Do you think people, including yourself live up to their full potential?

1365 Have you ever stayed up for an entire 24 hours, why?

1366 What creature do you admire for its ability to adapt?

1367 Who is a female role model in your life?

1368 What was your biggest "Ah-ha!" moment or revelation?

1369 How do you feel about GMOs?

1370 Do you prefer popcorn or candy with your movie or something else?

1371 How often do you reevaluate your life?

1372 What gives you a zest for life?

1373 What do you have trouble seeing clearly in your mind?

1374 What's your favorite place just to hang out?

1375 Do you believe in just giving kids an allowance or do you think they should earn it?

1376 Have you ever made your own orange juice?

1377 Have you ever been to a farmer's market, if so what do you love to get?

1378 If you had to give up one food you really love for the rest of your life, what would you pick

1379 Would you rather have endless love or endless money?

1380 Name a famous person you wouldn't mind for a business partner.

1381 Do you have siblings, if not do you want some?

1382 What is your favorite name for a girl child?

1383 Are you a good judge of character?

1384 In a few short words describe what the word commitment means to you in dating.

1385 Have you ever come to a crossroads in your life and what were the two paths?

1386 What three things do you think of most each day?

1387 Would you ever sign a prenuptial agreement?

1388 Would you travel to space if possible?

1389 What does creativity mean to you? Is it free flowing or does it involve your heart and soul?

1390 Where is one place you'd never be seen?

1391 What or who do you sympathize with?

1392 Would you feel any different if you suddenly found out you were adopted?

1393 What was the best present you received?

1394 If you were prime minister/ruler of the world what laws would you make?

1395 Have you ever been stood up for a date?

1396 Have you ever helped someone through a breakup and if so how did you help?

1397 Do you like ice in your drinks?

1398 How are your manners, do you say please and thank you?

1399 How do you show hospitality when entertaining guests?

1400 What was your worst date ever?

1401 What is one good way to grab your attention?

1402 Do you believe in kissing on the first date?

1403 Have you ever gone back to a place that gave you horrible service, if so why?

1404 What crazy thing do you do when you think no one is looking?

1405 How many slices of pizza can you eat in one sitting?

1406 The quickest way to make you crazy is…

1407 Would you rather learn fencing or archery?

1408 What singer's voice gives you chills, in a good way?

1409 Have you ever made a ball of twine or rubber bands?

1410 Have you ever self-sabotaged, how?

1411 If you were going to become a doctor, what skill or trait would serve you well?

1412 Do you eat fast food, if so what's your favorite?

413 Do you goals and dreams energize you or exhaust you?

414 Are you usually on time for things or are you habitually late?

415 Do you have any hidden talents that would be considered strange?

416 What's your favorite Saturday morning cartoon?

417 Are you involved in your local community?

418 Do you think it's more important to know CPR or self-defense?

419 Have you ever witnessed a crime in progress, what kind of crime?

420 Would you choose a shorter life and be super rich or a longer life somewhat poor?

421 What instantly makes you not like another person?

422 Someone you want to walk a mile in your shoes.

423 Who is your ICE (in case of emergency) saved in your phone?

424 If you could bring one famous person back from the dead, who would you pick?

425 What celebrity man do you find ruggedly handsome?

426 What do you think is the most dangerous profession in the whole world?

1427 Does the term "settle down" scare you or give you comfort?

1428 Have you ever tried to get someone fired, if so why?

1429 How do you handle panhandlers?

1430 How tall is the tallest person you know?

1431 What is something you continuously procrastinate with?

1432 What's your favorite sport?

1433 What do you need more of?

1434 What upcoming life event are you excited about?

1435 What do you have a hard time visualizing?

1436 Do you prefer to live somewhere that has all four seasons of the weather?

1437 Do you think the grass is greener on the other side, or where you water it?

1438 What is one thing you'll never do in public?

1439 Do you think the Zombie Apocalypse could be real or is total make-believe?

1440 Are you scared of spiders?

1441 Would you prefer to ride on a motorcycle or in a helicopter?

1442 Are you genuinely happy for other people's (family or friends) success?

1443 What is the best thing to happen to you this year?

1444 What memory from your school days still troubles you?

1445 If you could do one thing for someone and there were no limitations, what would it be?

1446 What's on your mind these days?

1447 What is your favorite thing to eat for breakfast that is not considered breakfast?

1448 What would you do differently if you knew nobody would judge you?

1449 How are you still similar to your younger self?

1450 What historical figure would you love to see in 21st century life?

1451 What or who brings your wild side to life?

1452 What is something that is possible today which 20 years ago would seem impossible?

1453 Do you give money to street performers?

1454 On a hot summer day what cools you off?

1455 If you were captain of a ship, what would you call it?

1456 What is a responsibility you have that you don't want?

1457 What is something you want people to remember about you?

1458 What is your vision for you and your family's future?

1459 Do you stay in your comfort zone most times or do you constantly push boundaries?

1460 What is your most used phrase?

1461 Do you allow yourself enough spare time to do things you love, if not why?

1462 Do you think secret clubs exist and if so what kind of club/s do you think there are?

1463 Do you think prisoners in jail should work so they can earn money for their release?

1464 What is the most unusual thing you've ever eaten?

1465 What actor or actress would you want to play you in a movie of your life?

1466 Are you the kind of friend you'd want as a friend?

1467 Have you ever tried archery?

1468 If you were a world famous art or jewel thief, what would be your next heist?

1469 What gives you butterflies in your stomach?

1470 Who can you count on to tell you the truth when you need to hear it?

1471 What is something you fell in love with instantly, not a person?

1472 Have you ever used the yellow pages?

1473 Do you have any nervous habits?

1474 Who would win in a fight? Chuck Norris or Jack Bauer?

1475 Have you ever missed a good thing because you were focused on something else?

1476 Are you an over achiever or perfectionist?

1477 What does your "happy dance" look like?

1478 What makes you cry every time you think about it?

1479 Do you enjoy camping and if so where is your dream spot?

1480 Would you rather be the hero in a movie or the bad guy?

1481 How well do you handle yourself in formal settings?

1482 If you or your partner were pregnant, where would be the worst place to go into labor?

1483 What is your favorite love song?

1484 Do you think what a person tells a priest should be confidential, even if it's a crime?

1485 What is your favorite mythical creature beginning with the letter U?

1486 How many concerts have you attended in your life so far and which was the best?

1487 What do you feel should be mandatory for seriously wealthy people?

1488 What is one thing that doesn't add value to your life but you still do it?

1489 What still amazes you?

1490 What's something new you recently learned about yourself?

1491 What company or brand has the funniest commercials?

1492 Do you still listen to local stations on the radio or only streaming/playlist music?

1493 Could you tutor anyone in a subject?

1494 What moment from your life would make a good love song?

1495 What drains your energy really fast?

1496 What is a question you hate to ask?

1497 What was the most predictable moment of your life?

1498 What do you consider unforgivable?

1499 Have you ever attended an art opening or gallery opening, if so for who?

1500 What is the most bizarre thing you've ever Googled?

1501 What do you believe is the deadliest sin?

1502 Have you ever used money to influence anyone?

1503 What animal do you think is closest in intelligence to a human?

1504 Is there anything that you have told yourself is "off limits," if so what?

1505 What's the most thought provoking statement or question you've ever heard?

1506 Who makes you laugh without even trying?

1507 What do you think is the most harmful thing a person can do to their self?

1508 Are you easily offended?

1509 What is the most outside the box idea you ever had?

1510 Do you prefer to buy anything secondhand?

1511 What is something you love that is vintage?

1512 Name a fable that you can relate to?

1513 What news or media outlet do you trust?

1514 What was the last song you danced to?

1515 What is something people do you feel is the equivalent of playing Russian roulette?

1516 If you were a boss of many, would you want them to fear you or love you?

1517 Are you more of a homebody or a person about town?

1518 Do you like *Saturday Night Live* and if so who would you love to see as a new host?

1519 Your office or church is having a potluck dinner, what will you bring?

1520 Do you have money saved for a rainy day?

1521 What do you do when you feel the pressure of something is too much?

1522 What is the main thing you and your bestie have in common?

1523 What if any unusual objects have you swallowed?

1524 What do you think of *CNN?*

1525 At this particular moment whom do you miss most right now?

1526 What would you compare your imagination to (one word)?

1527 What do you think would be one of the best steps we could take to end world poverty?

1528 Would you ever live in a treehouse?

1529 What makes you nervous?

1530 What wild animal scares you?

1531 Do you try to protect your reputation or does that not matter to you?

1532 What occasion do you pig out on food?

1533 On a scale of 1-10 how polite would you say you are?

1534 If you were comfortably rich would you work hard for more or rest on your laurels?

1535 Do you believe environmental surroundings play a role in future success?

1536 Would you ever start a celebrity fan club and if so for who?

1537 Have you ever had a "this can't be happening" moment and what was it?

1538 What faux pas do you find socially unacceptable?

1539 What is your favorite sport beginning with the letter S?

1540 How do you feel about buying a home?

1541 What TV show/s have you binge watched?

1542 Do you think most jurors can be impartial when presiding over a celebrity's trial?

1543 What's harder today than it was yesterday?

1544 What was your worst brain fart moment ever?

1545 What was your blessing in disguise?

1546 What keeps you interested in your goals or dreams?

1547 What do you consider to be irresponsible?

1548 If you achieved all your life's goals, how would you feel?

1549 What do you think is your greatest contribution to society?

1550 Do you think beauty pageants are degrading to women or harmless?

1551 What words do you always struggle to spell correctly?

1552 Would you rather be a news anchor, weather man/woman or an on location reporter?

.553 What was the topic of the worst argument you've ever had?

.554 Do you vote in every election?

.555 Do you think there is always something to be thankful for?

.556 How do you feel about the statement, "Home is where the heart is."

.557 What is one thing you thought existed but doesn't?

.558 What creative source or outlet do you often visit to get fresh ideas or renew your creativity?

.559 What do you need to learn to make time for?

.560 What are your bad habits?

.561 What's the biggest personal change you've ever made?

.562 What is your favorite animal beginning with the letter A?

.563 If you could star in any play you choose what character would you want to portray?

.564 Are you a left brainer or a right brainer?

.565 Something you want to forget.

.566 How many serious relationships have you had?

1567 Have you ever left words unspoken that you later regretted?

1568 What's the most thoughtful thing you've ever seen done for anyone or yourself?

1569 Is your dad an embarrassing dancer?

1570 Can you believe in something without evidence?

1571 What antiquated invention do you still use?

1572 How do you feel about guys wearing pink?

1573 What do consider yourself an expert at?

1574 What is the worst book you ever read?

1575 Do you like braided hair or dreadlocks?

1576 Did your childhood shape you into who you are today?

1577 What is your favorite thing about nature?

1578 Do you think you're living your life to the fullest?

1579 What is your solid foundation?

1580 What trap do you keep falling victim to?

1581 Do you know the meaning of life?

1582 What would be your dream car?

1583 Have you ever had a roommate, if so what did you hate about it?

1584 Is there something you've tried to rectify but couldn't, if so what?

1585 Who do you feel is your kindred spirit?

1586 Do you appreciate and learn from criticism?

1587 Did you have a favorite teacher or a teacher who made a big impact on your life?

1588 Do you feel robbed in any area of your life, if so where and why do you feel this way?

1589 Where is your favorite place to get a massage?

1590 If the world had an apocalypse, could you hunt for your own food?

1591 What's your favorite thing to "add" to your soda or cola, cherries or something else?

1592 Do you think some people just want to be saved or rescued, why?

1593 Have you ever slept with a nightlight, if so do you still use it?

1594 What is your favorite item of clothing beginning with the letter B?

1595 What does your communication style say about you?

1596 What do you consider to be a feast?

1597 Do you still play with toys? If so what toy have you bought as an adult?

1598 If you had to bury treasure today, where would you hide it?

1599 Have you ever accidentally texted the wrong person and how did it turn out?

1600 What's your favorite pizza topping?

1601 What 3 musicians/singers do you feel contributed the most to music?

1602 If you could replace one body part with a bionic replacement which would you choose

1603 Does any particular song play in your head when you walk?

1604 Do you like classical music, if so do you have a favorite composer?

1605 Are you a creature of habit, how?

1606 Have you ever been approached by someone familiar yet you couldn't remember them

1607 Do you consider yourself above average, average or below average?

1608 What do you think would be the most boring job in the world for you?

.609 Do you snore?

.610 Have you or your parents been involved in any political rallies, events or protests?

.611 Have you ever built an igloo?

.612 How do you feel about people hunting big game animals like lions and elephants?

1613 What is best learning as you go?

1614 Do you currently have a blog, if so what's it about?

1615 Do you honor your commitments?

1616 What is your favorite parody?

1617 Have you ever had a pen pal and if so where did they live?

1618 What's the fanciest place you've ever dined at?

1619 What aroma or smell makes you feel alive?

1620 Do you see things in black and white or do you think there is a gray area in certain cases?

1621 Have you ever hurt someone on purpose, if so why?

1622 What good habits do you want to introduce into your daily routine?

1623 Are you a planner or spontaneous?

1624 What is the biggest compromise you've made in your life?

1625 What technology advancement is overrated?

1626 Do you know any magic tricks?

1627 If you were going to take up painting as a hobby, what is the first thing you'd try to paint?

1628 Do you think artists should censor their work so they don't offend anyone?

1629 What is the first thing you notice about other people?

1630 What is the best thing about being your gender?

1631 What do you feel people complain too much about these days?

1632 What is the meanest prank you've pulled on someone or had pulled on you?

1633 If you swapped genders for a day how would you spend it?

1634 What's the most valuable thing you own?

1635 Have you ever built anything, if so what?

1636 Do you believe in spanking as a form of discipline or never?

1637 What is one major political topic that you are undecided about?

1638 If you could instill one piece of advice in a baby's mind, what advice would you give?

1639 When you wake up in the morning what is your number 1 priority?

1640 Have you ever broken someone's heart?

1641 Do you eat after other people?

1642 There is Martin Luther King Jr. Day, etc. what historical figure should get a holiday?

1643 Why do you think bears hibernate?

1644 Do you prefer digital or rotary/analogue clocks?

1645 Does your family have a secret recipe and if so what's it for?

1646 What gives you chills every time?

1647 Beyond the titles that others have given you, who are you?

1648 What is your favorite luxury car or sports car?

1649 What is the rudest thing a person can do to another person in your opinion?

1650 What TV show really annoys you?

1651 What's the main thing on your bucket list?

1652 Do you prefer a natural approach to healing or do you think modern drugs work best

1653 What is the meaning of peace to you?

1654 Have you ever slipped on a banana peel?

1655 What type of contest do you think it would be fun to judge?

1656 What is your opinion of modern medicine?

1657 What do you think makes a good party host?

1658 In one word sum up society today.

1659 What do you do when you feel like you're stuck in rut?

1660 What drains your energy?

1661 If you had to design a playground for adults, what is one thing you'd put on it?

1662 If your significant other wanted to take a vacation without you, what would you say or do

1663 Are you attracted to intelligence or does it matter?

1664 Would you ever eat something alive or gross for money?

1665 What is taboo for you?

1666 If you could play God for a day, what's the first thing you'd do?

1667 What song would you say best sums you up?

1668 Who was better, The Beatles or Elvis Presley?

1669 When you make a decision do you stick to it or do you go back and forth?

1670 Do you feel where you're living now is the best fit for you?

1671 Which one of your friends do you think is the nicest?

1672 What is one way you've tried to conquer your fears?

1673 Where is the most magical place on earth in your opinion?

1674 Finish this sentence: If all else fails…

1675 Would you ever consider going back to school once you're over 50?

1676 What can someone learn from a baby boomer?

1677 Do you like stargazing?

1678 What do you take too seriously?

1679 Do you have any enemies?

1680 Do you think you have the capacity to learn how to fly a plane?

1681 What was the hardest change in your life you ever had to go through?

1682 Is there anything you wished would come back into fashion?

1683 If given your own show in Las Vegas what would you do?

1684 What specific thing makes you happy that would not make most people happy?

1685 How do you prefer your potatoes: baked, mashed, fries, scalloped, etc.?

1686 What do you feel connected to spiritually?

1687 What would the logo for your life look like?

1688 What do you do when you're stuck in traffic?

1689 Have you found the purpose of your life?

1690 What one trait do you have that will make you a great boss?

1691 Do you hoard anything, if so what?

1692 What is the cleverest phrase you know?

1693 Have you ever stood up for anyone?

1694 What do you think is worse, failing or never trying?

1695 How high can you jump?

1696 What book have you read that made you really think about life?

1697 If they were going to name a street sign after you, what would you want the name to be?

1698 What's the most creative excuse to get out of doing something you didn't want to?

1699 If you became a writer what would you want to write?

1700 Do you wear sunglasses indoors to look cool or stylish?

1701 Which fictional married couple from TV or cartoons best fits your parents' marriage?

1702 What would you consider a challenge for yourself that may be rewarding in the long run?

1703 Have you ever stiffed a waiter/waitress for bad service or because you were being cheap?

1704 Do you think society puts too big an emphasis on physical appearance?

1705 Can you do 10 revolutions of a hula-hoop?

1706 Do you get sucked into the problems of your family, and how do you wiggle out of them?

1707 What is one thing you've really wanted lately but haven't been able to get?

1708 What characteristics do you most respect in the opposite sex?

1709 Have you ever had to give someone devastating news, what was it about?

1710 Have you read anything by Agatha Christie, if so what book was your favorite?

1711 What is the most expensive thing you've ever lost?

1712 What is your favorite thing to do at the beach?

1713 If you were going to be invisible for a day, what would you do?

1714 What card game or game in general would you love to learn how to play?

1715 What is one of your favorite family traditions?

1716 How fast can you run?

1717 What seasonal food item do you love?

1718 Do you think after a certain age people should not be allowed to drive?

1719 If humans came with a warning label, what would yours say?

1720 What do you love most about summer?

1721 Do you prefer cats or dogs?

1722 What's your favorite aisle in the supermarket?

1723 Have you ever played *Apples to Apples*, if so what's the funniest answer you've heard?

1724 What is the most useless talent you have?

1725 Is there a new unreleased smartphone or electronic device you're excited to try?

1726 Do you think there will ever be a cure for cancer?

1727 Would you ever strike if you felt your employer wasn't treating you fairly?

1728 If you got into trouble and had to do community service, what would be the worst type?

1729 Do you play "brain games" that help exercise and strengthen your brain, if so what game?

1730 When was the last time you tried something new and what was it?

1731 Who can you be yourself around?

1732 Do you think parenting classes should be mandatory for all parents?

1733 What opinion do you have which would be very unpopular in the court of public opinion?

1734 If you were in the hospital who are the two people you'd want to be by your side?

1735 Do you have a festival or an event you look forward to each year that's not a holiday?

1736 Do you lick the yogurt or dessert lid?

1737 What movie director do you find completely disturbing?

1738 If you made a panic room, what would be some of the things found in there?

1739 Will you dye your hair if it starts turning gray?

1740 What is your favorite salty snack?

1741 Do you know how to ride a bike?

1742 Have you ever been in or had a food fight?

1743 Have you ever used someone and if so what for?

1744 Do you have a real life guardian angel, if so who is it?

1745 Have you ever been arrested, if so for what?

1746 Describe your sense of humor in one word.

1747 If you did ever have plastic surgery what procedure would you do?

1748 Have you ever had a prayer answered?

1749 What is your favorite brand of blue jeans?

1750 If your office had a show-n-tell for adults what thing would you be proud to display?

1751 What is your favorite type of casserole?

1752 What makes you keep your distance from someone or something?

1753 Do you watch any cooking shows, if so which ones?

1754 In what way are you too hard on yourself?

1755 If you wanted to live off the radar where would you live?

1756 If you could read one person's mind, who would it be?

1757 Can you do an impersonation of anyone?

1758 What was the most special handmade gift someone gave you?

1759 Did you ever have any pretend or imaginary friends?

1760 What are you a casual observer of?

1761 Do you correct people's mistakes?

1762 What technology are you excited about coming out?

1763 Did you play hide and seek as a kid, if so where was your best hiding place?

1764 Have you ever slapped someone?

1765 What is your favorite television station?

1766 What is a hobby you really want to try but worry you won't be good at?

1767 What is your favorite condiment?

1768 When did you last go to the beach?

1769 Have you ever been admitted to hospital?

1770 If you didn't want to serve jury duty, what's the most creative excuse you'd give?

1771 Do you have a "type" that you look for when dating a person?

1772 What is your favorite food beginning with the letter P?

1773 What's the most shocking moment of your life?

1774 What do you do when you're with someone and there is awkward silence?

1775 How old were you when you realized you had a gift and how did you express it?

1776 What TV show do you always watch re-runs of?

1777 Do you believe in fairies?

1778 Your potential new boss says buy me a gift with the budget of $20.00. What will you buy?

1779 Who is the protagonist in your life?

1780 How are you your own worst enemy?

1781 What promise have you broken?

1782 Do you blame someone or something for the way your life is turning out?

1783 How do you feel about photography?

1784 If you lived in a tower would you want a doorman or do you think it's unnecessary, why?

1785 How many pairs of shoes do you own?

1786 What band do you find timeless?

1787 If you were a double agent, what would be your code name?

1788 What is the scariest movie you've ever seen?

1789 If you were famous who would you be excited to get interviewed by?

1790 What was the last thing to make you feel angry?

1791 Have you ever rehearsed anything?

1792 If you were elected Mayor of your current city, what is the first thing you'd do?

1793 Does death scare you?

1794 Have you ever dieted, if so what diet did you try?

1795 If you had a year off of responsibilities, what would you want to do?

1796 When you're feeling sick, what makes you feel better?

1797 Have you ever gotten a warning about someone or something and ignored it, what was it?

1798 If you could have a themed birthday party, what would your theme be?

1799 What makes you stand out in a crowd?

1800 How did you meet the love of your life?

1801 What makes someone a good kisser in your opinion?

1802 What lesson to this day have you still not learned?

1803 What do you think is a good job for teenager just starting to learn responsibility?

1804 What's the oldest thing you own?

1805 Do you own any inflatable furniture?

1806 What movie did you love but could only watch once?

1807 If you got lost in the woods what would you do?

1808 Do you excel in what you do currently?

1809 What do you think came first, the chicken or the egg?

1810 Could you ever be a living organ donor?

1811 Would you swim with sharks?

1812 What would be your perfect day?

1813 How do you feel about the kind of work you're doing right now?

1814 Do you like photography or videography better?

1815 What would you do if you saw someone getting bullied?

1816 Do you have a favorite number? Any particular reason why you like that number?

1817 What organization or cause would you volunteer for?

1818 What is your favorite trip down memory lane?

1819 What would be the moral of your story?

1820 What has been the biggest blindside in your life thus far?

1821 What does your style say about you?

1822 Which form of public transport do you prefer?

1823 Elementary through high school, what grade was the hardest for you?

1824 Do you always do the right thing?

1825 Do you think there will ever be a more sustainable substitute for gasoline? If so, what?

1826 Have you ever lost your faith in humanity, if so what caused it?

1827 If you were a geometric shape which would you be?

1828 What do you keep on your desk or workspace area that boosts your mood?

1829 What's in your perfect trail mix?

1830 What is one thing you think every human being should learn how to do?

1831 What non-profit organization would benefit from your skillset?

1832 What always puts a smile on your face?

1833 What do you think was the ugliest car model ever created?

1834 What would be the coolest design for a birthday cake?

1835 How do you feel about plastic surgery?

1836 What is the most outrageous question you've ever been asked by anyone?

1837 Do you think chivalry is dead...should it be?

1838 What food item do you no longer allow yourself to eat?

1839 What makes you feel unstoppable?

1840 Do you think it's better to be an only child or have siblings?

1841 How good are you at giving directions?

1842 What do you doubt more than anything?

1843 What is the craziest thing you'd do in a limo?

1844 What makes you proud?

1845 What are two funny traits about your mom you can describe?

1846 Have you ever won anything, if so what?

1847 If you lost everything you worked for tomorrow, what's the first step in starting over?

1848 Something you believe in that others think is not real.

1849 What social media platform are you most active on?

1850 What's the simplest way you have fun?

1851 Do you think two people that don't speak the same language could be in a relationship

1852 Does the sight of blood make you queasy?

1853 What is a promise you know you'll never break?

1854 Do you think you need to slow down and enjoy life more?

1855 How do you cope with loss or death?

1856 What book from your childhood book would you want to read to your children?

1857 What moment from your life would you love to live over and over?

1858 What news story are you tired of hearing about?

1859 How did you meet your significant other (if single, your last one)?

1860 Who made the worst first impression on you but then later became your friend?

1861 Would you rather be hated or forgotten?

1862 How do you handle negative influences in your life?

1863 If you were going to speak to a group of graduating teenagers, what would be the topic?

1864 What insulting term or word do people use very cavalier today?

1865 What is your favorite personality trait you like about yourself?

1866 Have you ever been caught in a compromising position? Even despite a valid explanation?

1867 Do you know how to use a compass, and how well?

1868 Do you like hot or cold food better?

1869 Do you jog or walk regularly, if so where is your favorite place to go for a run?

1870 Do you know how to use any weapons, if so which ones?

1871 What is your favorite movie quote?

1872 Do you think science is cool or creepy?

1873 When you look into the mirror, what's the first word that comes to mind?

1874 How did your parents meet?

1875 Who is the one person you hug that you don't want to let go?

1876 When you were in grade school did you bring your lunch or buy it from the school?

1877 In a disagreement, do you think it's better to be right or peaceful?

1878 Is it better to give than receive in your opinion or are you the opposite?

1879 Do you have a lawyer?

1880 Are you the kind of person to step in and try to break up a fight?

1881 If you had to take a couples class, what kind of class would be fun to take with your boo

1882 What's the tallest building you've ever been up?

1883 What is one thing you wish you knew about your grandparents?

1884 What is your "go-to" comfort food?

1885 Worst thing you've eaten at a dinner party?

1886 Do you think money is the root of all evil?

1887 What do you hope for?

1888 Who do you hope to forge a relationship with business or otherwise in the future?

1889 Can you do any fake accents, if so which one?

1890 What home design trend do you love?

1891 What do you feel very protective of?

1892 Have you ever loved two people at one time and were conflicted about whom to choose?

1893 What do you compartmentalize in your life?

1894 What is your most favorite random fact?

1895 Who is the strangest person you've ever met?

1896 Are you a drama king or queen?

1897 Have you ever been in a fight?

1898 What do you dislike most about the current city you live in?

1899 Do you let your conscience guide you?

1900 Have you ever wielded a sword?

1901 When have you answered someone's cry for help?

1902 Do you often help people when they ask or does there have to be something in it for you?

1903 Do you think you could write a song, if so what would it be about?

1904 Do you put up a boundary on any area of your life to keep people out?

1905 If you had a chance to marry royalty would you, even if you weren't in love?

1906 Who do you feel like you have the strongest unspoken bond with?

1907 Have you ever blackmailed someone, if so with what?

1908 What is some of the most important work being researched on our planet in your opinion?

1909 Have you ever won a giant sized toy from a fair?

1910 Have you ever been caught in a love triangle, if so with who?

1911 Do you know the valedictorian of your high school class and where are they now?

1912 What is your most used word?

1913 Do you prefer flowers or plants or both?

1914 Do you like cheese, if so what is your favorite kind?

1915 Do you think there should be special laws for the paparazzi?

1916 Are you introverted or extroverted?

1917 What is the trait you most deplore in others?

1918 What brings out your silly side?

1919 Do you trust things you read online, if so what is your most reliable source?

1920 Do you do what you say you're going to do?

1921 What would you hire a private detective for?

1922 What is childish but you still do it anyway?

1923 What is one thing you'd recommend people not try or do?

1924 Whom do you secretly envy?

1925 If you found a purse with $100 on the floor, would you turn it in?

1926 Do you have a favorite figurine or action figure, if so who is it of?

1927 Do you buy recycled products and goods and how do you feel about it?

1928 What villain from history do you think was misunderstood?

1929 Have you ever gone on a sightseeing tour, if so where?

1930 If you could have fame but not control of your career, would you still want to be famous?

1931 Do you have a hard time telling people no?

1932 Would you ever consider becoming a preacher?

1933 What do you do when you get really angry?

1934 If you could do something all over again, what would it be?

1935 Have you ever received or bought a gag gift, if so what was it?

1936 Life is too short so you need to stop and...

1937 What is one thing you will never give up on?

1938 What is your favorite gum?

1939 What table manner do people lack that drives you crazy?

1940 Do you need to learn how to say NO more often?

1941 What do you think every couple should do on their honeymoon?

1942 Was there something you asked for repeatedly as a child, that you were always told no?

1943 Do you think a person can always depend on the kindness of strangers?

1944 Have you ever thrown a temper tantrum until you got your way?

1945 What strokes your ego?

1946 How sophisticated are you?

1947 If you live to be 100 years old, will you want to do something extra special?

1948 What kind of driver are you?

1949 What is your biggest turnoff?

1950 When you lose touch, what snaps you back to reality?

1951 If you could afford a personal driver to drive you everywhere, would you get one?

1952 Who do you think has done the most for human rights throughout history?

1953 What is one thing you'd never do for all the money in the world?

1954 Could you marry someone with different political beliefs than your own?

1955 What is the greatest peer pressure you've ever felt?

1956 Have you ever been a part of a team and how'd that make you feel?

1957 Have you ever done a criminal background check on someone you've dated?

1958 What should kids be sheltered from, if anything?

1959 What are you worried will change you?

1960 What triggers your inner shopaholic?

1961 Do you have a scar, if so how did you get it?

1962 What part of democracy do you not agree with?

1963 How cynical are you?

1964 If you need to come up with a large amount of money in 48 hours, how could you do it?

1965 What do you feel needs further exploration in our world or universe?

1966 Who is the smartest person you know and what do you ask them for help with?

1967 What is the hardest thing about being YOU?

1968 How tall are you?

1969 How would you rate your athleticism using fictional characters?

1970 Have you ever given a speech, if so what about?

1971 Have you ever declared a truce with someone you were fighting with?

1972 Have you ever run into a wall or door?

1973 How would you describe your sarcasm?

1974 Do you like to meet new people?

1975 What new TV show recently released do you love?

1976 Why did you choose your current profession?

1977 What's your favorite holiday time cartoon?

1978 Are you conservative, liberal or somewhere in between?

1979 If you were given $1,000 to spend on your closest friend, what would you get them?

1980 Have you ever gotten in a bidding war on Ebay, if so for what item?

1981 Can you do any tricks with your tongue?

1982 What is a recent compliment you've received?

1983 Who is your favorite radio DJ?

1984 Do you think a little competition is healthy?

1985 What is the ultimate cake topping?

1986 Where is heaven on earth in your opinion?

1987 Do you believe in heaven and hell?

1988 What has been your worst haircut/style?

1989 What were you doing exactly a year ago that's different than today?

1990 Is there a family member who you don't associate with anymore, and why?

1991 What do you think is the most beautiful word?

1992 Have you ever ridden on a motorcycle, would you?

1993 Are you friends with any of your ex's?

1994 Who would you want to be stranded on an island with?

1995 What are you good at guessing?

1996 What does "The American Dream" mean to you?

1997 Have you ever had a brush with insanity, how?

1998 If you wrote an excerpt about the craziest day of your life would it read as fact or fiction?

1999 Have you ever been a bartender, would you?

2000 What is the last thing someone talked you into doing that you didn't want to do?

Looking for more?

Similar titles available by Piccadilly:

300 Writing Prompts

300 MORE Writing Prompts

500 Writing Prompts

3000 Would You Rather Questions

Complete the Story

Your Father's Story

Your Mother's Story

The Story of My Life

Write the Poem

Write the Story

300 Drawing Prompts

500 Drawing Prompts

Calligraphy Made Easy

Comic Sketchbook

Sketching Made Easy

100 Life Challenges

Awesome Social Media Quizzes

Find the Cat

Find 2 Cats

Time Capsule Letters

WWW.PICCADILLYINC.COM